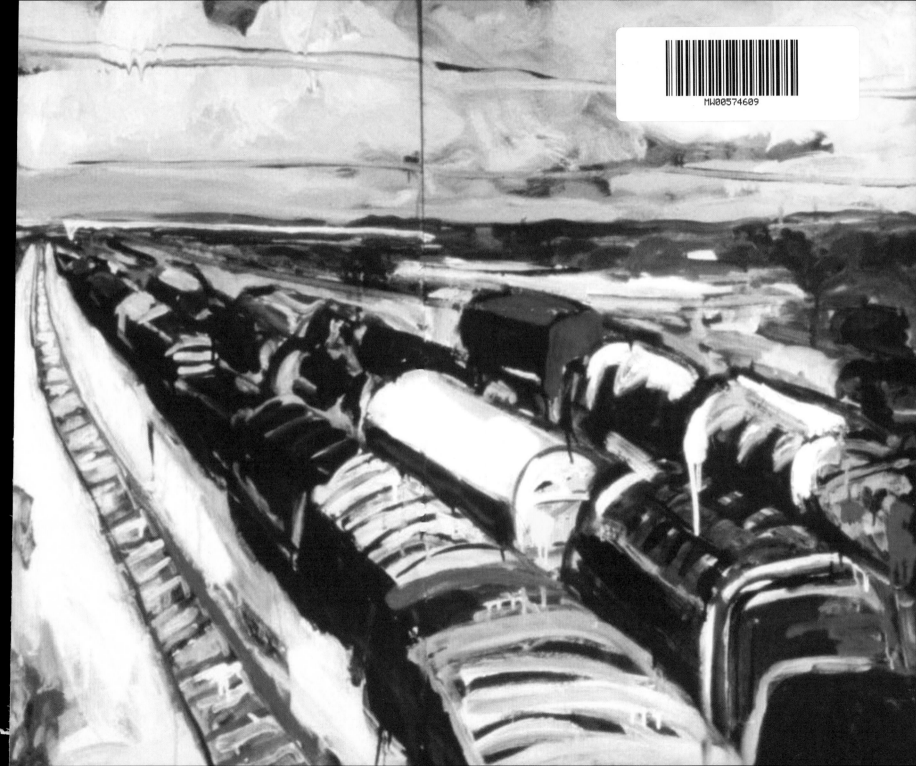

# Transcendental Train Yard

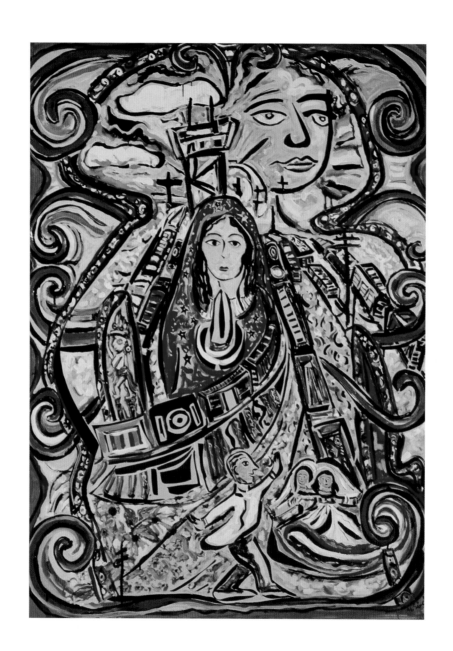

# Transcendental Train Yard

## A Collaborative Suite of Serigraphs

Art

### Marta Sánchez

Poetry

### Norma E. Cantú

WingsPress

San Antonio, Texas

2015

*Transcendental Train Yard* © 2015 by Wings Press for Marta Sánchez and Norma E. Cantú

All artwork is by Marta Sánchez and is used by permission of the artist.

First Edition

Hardback Edition ISBN: 978-0-916727-97-0
ePub ISBN: 978-1-60940-228-0
Kindle ISBN: 978-1-60940-229-7
Library PDF ISBN: 978-1-60940-230-3

Wings Press
627 E. Guenther
San Antonio, Texas 78210
Phone/fax: (210) 271-7805

On-line catalogue and ordering:
www.wingspress.com
All Wings Press titles are distributed to the trade by
Independent Publishers Group
www.ipgbook.com

Library of Congress Cataloging-in-Publication Data:

Sánchez, Marta, 1959-
  Transcendental train yard : a collaborative suite of serigraphs / art by Marta Sánchez ; poetry by Norma E. Cantú ; preface by Tomás Ybarra-Frausto ; supporting essays by Peter Haney and Constance Cortez. -- First edition.
     pages cm
ISBN 978-0-916727-97-0 (hardback/cloth : alk. paper) -- ISBN 978-1-60940-228-0 (e-pub ebook) -- ISBN 978-1-60940-229-7 (mobipocket/kindle ebook) -- ISBN 978-1-60940-230-3 (library pdf)
1. Sánchez, Marta, 1959---Themes, motives. 2. Railroads in art. 3. Mexican-American Border Region--Art. 4. Railroads--Poetry. 5. Mexican-American Border Region--Poetry. I. Cantú, Norma E., 1947- II. Ybarra-Frausto, Tomás, 1938- writer of preface. III. Haney, Peter. IV. Cortez, Constance, 1958- V. Title.
     NE2237.5.S26A4 2015
     769.92--dc23                                               2015019430

Printed in China.

# Contents

# Transcendence

**L**uis Meza, my grandfather, worked for the Union Pacific Railroad as an upholsterer all his adult life. One of the benefits of that job was that, through his various friends at work, he could arrange a short train ride for me in any car that I selected. Of course, I chose the caboose. It was the end car and from that perspective you could see the whole train and the track up ahead until it disappeared into a vanishing point.

I leaned my head out the window and I don't know if it was the effect of the wind rushing past my ears or the rumble of the train or the mantra of the click-clack of the steel wheels against the rails, or maybe the combination of all three, but it was the first time that I had ever experienced this feeling that I would come to learn was called … transcendence.

Thank you, Marta and Norma, for your work that let me experience this same feeling that I thought I was way too old for.

— Cheech Marin
**Comedian, actor, voice actor and art collector**

# Preface

## Of Trains and Train Yards: Recuerdos y Memorias of San Antonio

### Tomás Ybarra-Frausto, Ph.D.

The visual and literary texts collectively produced by Marta Sánchez and Norma E. Cantú in the *Transcendental Train Yard* suite affirm the centrality of the railroad in Mexican and Mexican-American history and culture. Their expressionistic, dreamlike representations bring to consciousness reservoirs of feelings and primordial images from the Mexican collective unconscious. The prints evoke pictorial sources such as the photographic chronicles of the Mexican Revolution compiled by Agustín Victor Casasola. Our mind organizes these photos like a film: we see trains carrying masses of soldiers, campesinos, and women soldaderas riding on top of railroad boxcars en route to battle fronts across the Mexican landscape during the cataclysmic days of the Revolution. I can't think of railroads without thinking about the life and work of Martín Ramírez, a Mexican immigrant and railroad worker who made art while imprisoned in mental hospitals. His hallucinatory landscapes center on images of trains that cross through tunnels and over bridges, joining fantasy and memory.

In Mexican collective memory, trains are perhaps the defining symbol of immigration. They took sons away from parents, and fathers away from wives and children. The same scenarios were duplicated in Mexican American communities throughout the Southwest as workers left the region to work on railroad crews doing back-breaking labor "en el traque," laying rail tracks for railroad companies throughout the country. Many corridos use the train as a metaphor for separation while narrating the adventures and misadventures of laborers in the fields, factories, and train yards of an urbanizing United States. Men working on the railroad brought their families to the rail yards, where they lived and worked. Mexican American enclaves evolved into stable rail-side communities.

The reveries prompted by the railroad prints brought me back to my childhood. I grew up in the Westside colonias (neighborhoods) of San Antonio in the mid-1940s and 50s. Among the many happy memories of my elementary school days, one scene keeps recurring in the recesses of my mind. I remember being snugly warm in my bed on winter mornings, awake, yet lingering lazily, in no hurry to get to school. From the kitchen I hear the reassuring clop clop of my mother's palote (wood rolling pin) hitting the tabla (bread board) as she rolls

out the masa (dough), to make the stack of flour tortillas for the day. In the distance the sound of a melancholy train whistle slowly fades away. In the safety of mi casa, all seems well with the world.

"El Dipo" is what we called the Southern Pacific depot, located on East Commerce and Medina Street. This historic San Antonio landmark looms large in my childhood memory because of the iconic statue of an Indian brave that crowned the depot's copper dome. The Indian was gracefully balanced on one foot as he shot an arrow from his bow. We saw "el indio" on many weekends when my family (parents and three children) went shopping "al centro" (downtown). As soon as we crossed the Commerce Street overpass, "el indio" came into view. Mother would remind us that he would shoot his arrow at one of us if we didn't behave. Her admonition always worked; our chattering stopped and we rode in quiet solemnity, peering at the Indian until he disappeared from view.

My recollections flow from the words and images in the rail-yard portfolio. Ultimately, trains became vehicles for meditations on absence and return, labor and celebration, rootedness and uprootedness, homeland and immigration, and the human desires to belong and to find completion. This is what the suite *Tanscendental Train Yard* does; it invites us to reminisce, to meditate on these issues and to dwell in our memories.

---

Tomás Ybarra-Frausto has taught at the University of Washington, Stanford University, and the University of California/San Diego. A life-long activist, he has helped to establish programs across the country that support Chicano identity, education and employment, especially in academia. His work on "Rasquachismo" was especially important in defining a Chicana/o aesthetics. Named the 2009 Scholar of the year by the National Association for Chicano and Chicana Studies (NACCS), he has also been the Associate Director of the Creativity and Cultures at the Rockefeller Foundation and the Chair of the Mexican Museum of San Francisco. In 1998 he received the Henry Medal from the Smithsonian Institution in recognition of his contributions.

## Marta Sánchez

**M**y vision for this work was to create a collaborative suite with my friend, scholar and poet Dr. Norma E. Cantú. Together we began to work on a series of prints and poems. In addition to our frequent conversations about the topic of the train yard, our collaboration included correspondence in which Dr. Cantú would offer poems responding to my prints, and I would then respond to her poems with new prints. Our goal has always been to widely distribute the set by placing editions in university libraries, art departments, and Latin American studies programs throughout the United States. We sought to prompt a dialogue about the train yard that could, in turn, create a historically significant narrative of the Mexican American experience. The idea of turning the series into a book grew out of the request from various friends and scholars for a more accessible format of the suite prints. We approached Wings Press and were very glad that we were able to collaborate on the product you hold in your hands.

Throughout my life, the view from my parents' front porch has been the train yards of San Antonio, Texas. My earliest childhood memory is of a very active train yard. My fascination with the setting began as I witnessed the comings and goings of the trains of cargo carriers. But my imagination has also been driven by other train yard observations: I wondered how the train brought the circus, or a hobo who would occasionally knock on our door to ask for a sandwich in exchange for performing some minor home repairs. Blanca Estella, my mother, would give these men cheese sandwiches and let them eat on our porch, as I remained inside with my brothers and sisters peeking through the Venetian blinds. This landscape had a rhythm to the train's movements that rattled the ground. The whistle became a marker of time as the train announced a move.

Over the years these sounds became both less frequent and yet somehow more pronounced as they interrupted the still of the night. On my parents' porch I would often sit and draw images of the various lights and seasonal effects of what was, to me, a landscape alive with mysteries. As I drew, my mind would become active and I imagined where the trains might be going, where they had come from, and what and who might be on board.

On one of my last visits to my father in the late 1990s, I stared in disbelief as he told me—as we were eating sandwiches at lunch—about his grandfather, who had been a lion tamer in a circus in Mexico City. Until then, I had no idea that there had once been traveling circuses that came to the United States from Latin

America. I listened with mixed feelings of doubt, amusement, pride, and curiosity as, at that moment, my need to embrace this subject became a passion. I felt an urge to honor my great-grandfather, to please my father, to increase my knowledge of the history of my people, and to introduce others to a topic that is now so ingrained in my work and heritage. I began to research the history of these circuses and to examine the subject within my paintings, drawings, and prints. Although I have always attempted to incorporate the images of my own background into my work, my lifelong fascination with the train yards combined with my family connections, led me to the subject of traveling circuses. This theme empowered an investigation that fulfilled both my need for my work to have a cultural relevance and my desire to connect to my subject in a deeply personal way.

During my visits to San Antonio over the past ten years, I have often documented the train yard as a form of rural landscape. I have been introduced to many Latin American historians who have expanded my understanding of such fascinating aspects of the train yard such as the vaudeville-like carpas that came to San Antonio and points north via the train. It was this journey that my great-grandfather had undertaken and that ultimately tied me to the trains and train yards. What began as a casual lunchtime conversation with my father grew to become an integral part of my life as, over many years, I continued to involve the train yard and all it represents in my work. Each time that I find myself drawing or photographing the area, I realize that I am mesmerized, that I am in a state of mind that is solemn and comforting. I have heard the sounds of the train yard from my conception. Was it the pattern of tracks and trains that creates the kind of uniformity that can hypnotize? My adult home in Philadelphia is next to the train tracks, and I still find the sounds of trains comforting. Did I agree to purchase this house because of its location adjacent to the tracks? My life formations and my childhood home allow me to see the trains and the tracks as a natural landscape, a landscape that is etched in my very being.

Perhaps because I am an artist, I see in images: the brilliant sun that hits the ground and makes the rocks and metal glow, the wooden ties lying like tired, sun-beaten bodies waiting for the spiritual skies to lift them up with a cool breeze. This landscape, like many, is in constant flux, changing slowly and quietly in the dusty hot South Texas sun. This is why I was compelled to bring the train yard into my art, to serve as a backdrop to my early narratives. Each time I work with this subject, the process becomes a visual embrace of home, a homage to my father, who passed away quietly at home one night amongst the train's white noise.

One of the major influences on the development of my artistic vision has been my interest in the early "Golden Age" of Mexican films of the 1940s and 1950s, as well as the surrealistic films by Luis Buñuel that convey so well the spirit of their time and sparked my own interest in literature and poetry. I love the surrealistic Mexican cinematography that reflected social and political messages. Also, I am formed by reading the works of contemporary Latin American and Chicana/o writers. The Chicano movement portrayed by the filmmakers and writers established a fertile ground for creative arts of all disciplines. My exploration of these various ap-

proaches has rewarded me with a crucial understanding of my Mexican and Chicana experiences and of how and why I have chosen to depict the train yards.

When I spoke to a fellow Chicana artist about my emotional response to this now almost barren landscape of old trains and tracks she said, "Remember this land was once part of Mexico; the lives and spirits of the Lipan Apache, or Coahuiltecans, our indigenous ancestors who are buried there, may be emitting their essence."

The more I have learned from other people's experiences, the richer this project has become. I eventually stopped trying to tell a story and instead allowed the images to speak for themselves. As I painted and drew, I found myself with a puzzle that I wanted to decode in a different way.

A few years into the development of these series of landscapes, I had the pleasure of meeting Dr. Norma E. Cantú while visiting my friend Santa Barraza in New York. I later read her book *Canícula: Snapshots of a Girlhood en la Frontera.* I liked the rhythm of the book and felt attuned to her writing; I invited her to collaborate on this train yard series not knowing where it would lead us. We had a common bond with the train yard. While my experience was mainly with its familiar landscape and daydreams of my great-grandfather Ignacio Mata, the lion tamer, and his wife, Luz Becerra, a dancer in a Carpa troupe, Norma's connection was to a grandfather who worked in the same train yard.

Dr. Cantú adds not only poetic text to the project, but also insight to the historical events of the Mexican experience with the train yards. She brought light to the history of women and men living in empty train cars and working in the yards. Together we worked every few months, exchanging images and text. I would create an image and send it to her, and she would create a poem for each image as a response, more than a description, of what she saw. We were striving to present the image as a vehicle to tell more than what was just in front of us. She offered a translation and reaction of her own to the visual images I produced. Her response to figures on the page, to the moon, like a tarot card with her own reading, very much to what I learned to be a Gloria Anzaldúan approach to writing and visual art making. We were scratching the surface and creating detouring images to fit with compositions and words. I am very grateful to have had this opportunity to work with such a talented poet, folklorist, and friend.

I would also like to thank Dr. Tomás Ybarra Frausto, Dr. Antonia Castañeda, and Dr. Arturo Madrid for their assistance and support in this project. With their help I was able to meet other Chicana/o writers, historians, and anthropologists interested in this topic and willing to share their research with me. I am also grateful to Dr. Peter Haney for his collaboration in the form of an essay on the train yards. In particular, I give my thanks to Sam Coronado, Marie Gomez, and all the studio assistants at Coronado Studio in Austin who made the creation of the collaborative boxed set possible. Were it not for them, the book project would not have happened, as the studio plays a key role in the Chicana/o and wider Latino/a art community; their patience and support was priceless. They welcomed me anytime I was able to visit Texas to proof the prints. They helped me send my

work from Philadelphia, and most importantly, they were the lifeline connecting me with my beloved Texas and the comunidad, for which I long. This book project is an extension of the collaborative boxed suite of prints; it gives the project new life and I am grateful that it will continue to live outside of the box.

## Norma Elia Cantú

*W*hen **Marta approached me** about the train yard project, I was hesitant. While I had collaborated on scholarly projects, my creative endeavors had always been solo projects. However, the project intrigued me. My interest grew as we walked the train yards one sunny June day. I took photos of the trains, heard the whirring and grating sound of metal against metal and smelled the distinctive fuel odors of the engines. That afternoon, I knew I wanted to do it. My writing has always been spontaneous and serendipitous. Coming from me and through me. These pieces attest to it.

I was unclear as to what Marta intended for us to do. Initially, I shared with her poems from a manuscript that remains unpublished, "Border Meditation/Meditación fronteriza: Poems of Love, Life and Work." She selected some of them and used them on the first prints. I was ecstatic when I saw the results. I knew then that we were doing something significant. Subsequently, she would send me the images via e-mail and I would write the words for the image. "Soledad" was written at Coronado Studios shortly after my father had passed on; I felt her father's absence in her life as my own; it was such instances that affirmed for me that our collaboration was exactly what we both needed to be doing at the time.

No doubt the memory of the trains and the yards were in my cellular memory, embedded with the smells and the sounds that my maternal grandfather lived. In San Antonio, my mother, as a girl, lived near the yards. I have always found comfort in the distant din of a train wherever I have lived—Laredo and San Antonio, Texas; Washington, D.C.; Santa Barbara, California; Lincoln, Nebraska; Madrid, Spain. My grandfather, Maurilio Ramón, was a railroad man who worked in San Antonio in the 1920s and 30s. He would tell us stories of going to Odessa or to Waco and other exotic and racist towns to lay track. He worked for Southern Pacific and only left when there was a dispute with the bosses who gave his well-deserved promotion to a white man and not to him. It was the Depression, and my maternal family's destino was changed forever when they moved to Rodríguez, Nuevo León, a rural town in northern México, where my father would later meet and woo my mother. My childhood home on San Carlos Street was two blocks from the railroad tracks, and as I was growing up, the sounds of a train marked the rhythms of our day and night. As children we would place pennies on the railroad tracks that would then be flattened out. It was a dangerous and exciting game.

Marta in Philadelphia. I in San Antonio. Close friends, artists, working together but apart.

I dedicate this work to my maternal grandfather Maurilio Ramón, who worked on the Southern Pacific Railroad in South Texas in the 1920s and 30s and to my grandmother Celia Becerra, who was with him every step of the way. Finally, to all workers who labor(ed) to make the railroad what it is.

Norma Elia Cantú

I dedicate this to my family on Seguin Street. To Papa Joe and Stella, my parents, who bought the house I was born in and gave me a history to discover. To my sisters and brothers, Rosario, Maria, Joe Michael, and Freddy, who share all the childhood memories of playing, sleeping, and dreaming together by the train yards. We listened together as the cargos traveled on to destinations unknown. To my husband, John, and son, Phillip Ignacio, who continue to give me support, hope, and appreciation for whatever lies beyond the horizon.

Marta Sánchez

# Transcendental Train Yard

## A Collaborative Suite of Serigraphs

## PRELUDE ✻ PRELUDIO

Fiery gold crown sunset over Mexico
death defies life.
A packed train speeds by
transports precious cargo
arrives with the moonlight.

El ocaso es corona de oro ardiente
que cae sobre México.
La muerte, un desafío a la vida.
Retacado el tren pasa
transporta carga preciosa
llega con la luz de la luna.

2

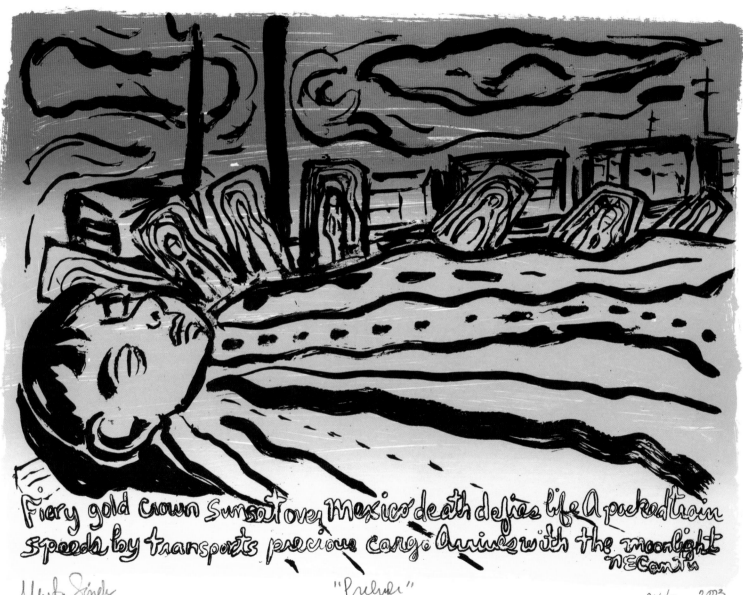

Fiery gold crown sunset over Mexico death defies life A packed train
speeds by transports precious cargo Arrives with the moonlight
NECantú

Marta Sánchez                    "Prelude"                    24/50  2003

# MOONLIGHT ✣ LUZ DE LA LUNA

Moonlight Vigilant guardian,
Luna guerrillera,
we ask,
we plead,
soften the pain
with your light,
Coyolxauhqui help us
remember our true selves
¡Gracias!

Luz de luna, guardián vigilante,
warrior Moon,
te pedimos,
te suplicamos,
suaviza el dolor con tu luz,
Coyolxauhqui ayúdanos
a recordar nuestro verdadero yo
¡Gracias!

4

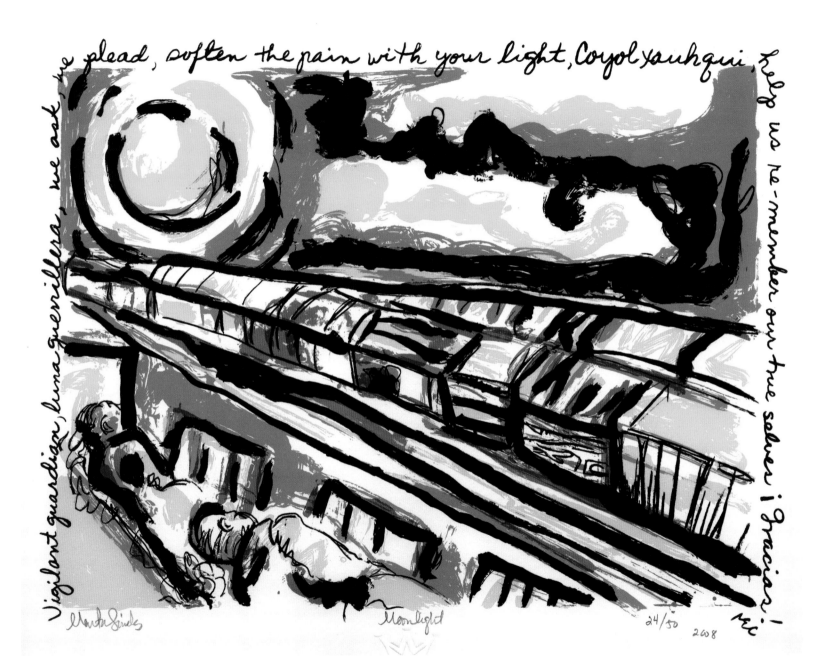

We plead, soften the pain with your light, Coyolxauhqui, help us re-member our true selves! ¡Gracias! Vigilant guardian, luna guerrillera, we ask

Moonlight

24/50
2008

Women's Work is never done—
at home in the fields, at the office.
We are workers all.
Doing work that matters.
Protesting wars, writing poems,
doing laundry, fighting injustice,
breaking bread, living.
Blanca Estela Sánchez, Emma Tenayuca,
Manuela Solís, Sor Juana Inés de la Cruz,
Dolores Huerta, Jovita Idar, Sara Estela Ramírez,
Gloria Anzaldúa, Audre Lorde, Rosa Parks,
La Adelita, Rosario Ybarra, Virginia Cantú.

El quehacer de la mujer nunca se acaba:
en el hogar, en los campos, en la oficina.
Somos obreras, todas. Elaborando tareas importantes.
Protestando contra las guerras, escribiendo poemas,
lavando la ropa, luchando contra la injusticia,
horneando el pan, viviendo.
Blanca Estela Sánchez, Emma Tenayuca. Manuela Solís.
Sor Juana Inés de la Cruz. Dolores Huerta. Jovita Idar.
Sara Estela Ramírez. Gloria Anzaldúa. Audre Lorde.
Rosa Parks. La Adelita. Rosario Ybarra. Virginia Cantú.

At the office. At the factory — We are workers all — Doing work that matters. Protesting wars, Writing poems, doing laundry, fighting injustice, baking bread, living

Sor Inés de la Cruz. Dolores Huerta. Jovita Idar. Sara Estela Ramírez. Gloria Anzaldúa. Audre Lorde. Rosa Parks. Rigoberta Menchú. Rosario Ibarra. Virginia Cantú. ...

Women's work is never done. at home. In the fields. At the office. At the
Blanca Estela Sánchez. Emma Tenayuca. Manuela Solis. Jo...

Maria Sánchez          "Mujeres Trabajando"          24/50 2008

# LA CENA ✒ DINNER

Alone with others a (wo)man forgets
(s)he is not alone.
Juntos. ¡El Pueblo Unido.
Sí.  No.
Jamás será vencido.
Juntos
we eat, meet, talk, sing.
Somos nada.
Somos todo.

Sola/o y con otras la mujer/el hombre se olvida
que no está sola/o.
Together. The people United.
Yes. No.
Will never be defeated.
Together
comemos, nos reunimos, hablamos, cantamos.
We are nothing
We are everything.

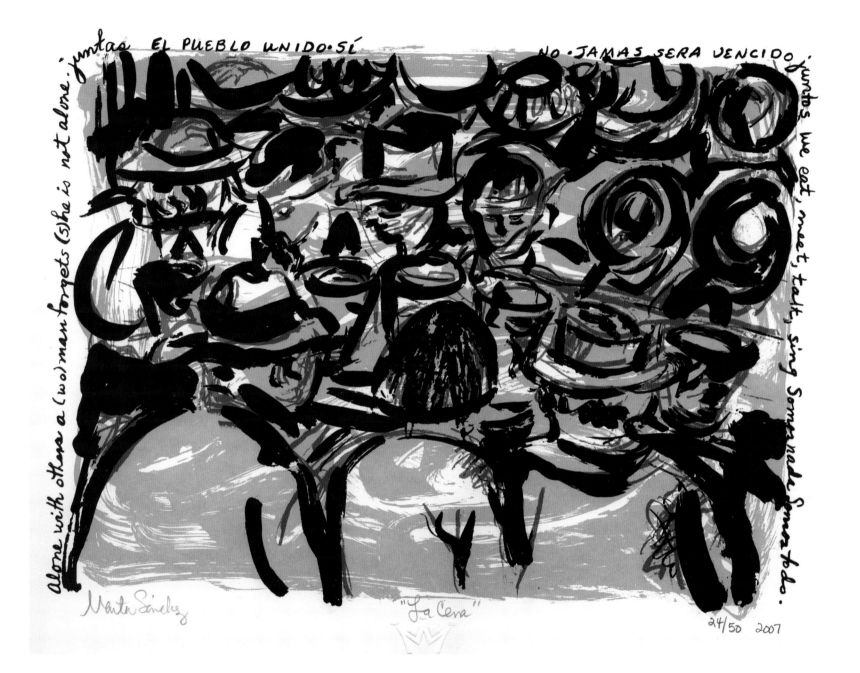

EL PUEBLO UNIDO·SÍ

·juntas· "Alone with others a (wo)man forgets (s)he is not alone."

NO·JAMAS SERA VENCIDO·

·juntos, we eat, meet, talk, sing Somos nada · Somos todo.·

Marta Sánchez

"La Cena"

24/50 2007

# WORKERS ON THE TRACK ❧ TRABAJADORES EN LA VÍA DEL TREN

Workers son y serán,
the salt of the earth.
Trabajan, se ganan
el pan de cada día,
se ganan el cielo.
Se ganan, se pierden,
se buscan, se encuentran.
Son y serán.

Workers are and will be,
the salt of the Earth.
They work, they earn
their daily bread,
they earn heaven,
they earn, they lose.
They search, they find themselves.
They are and will be.

10

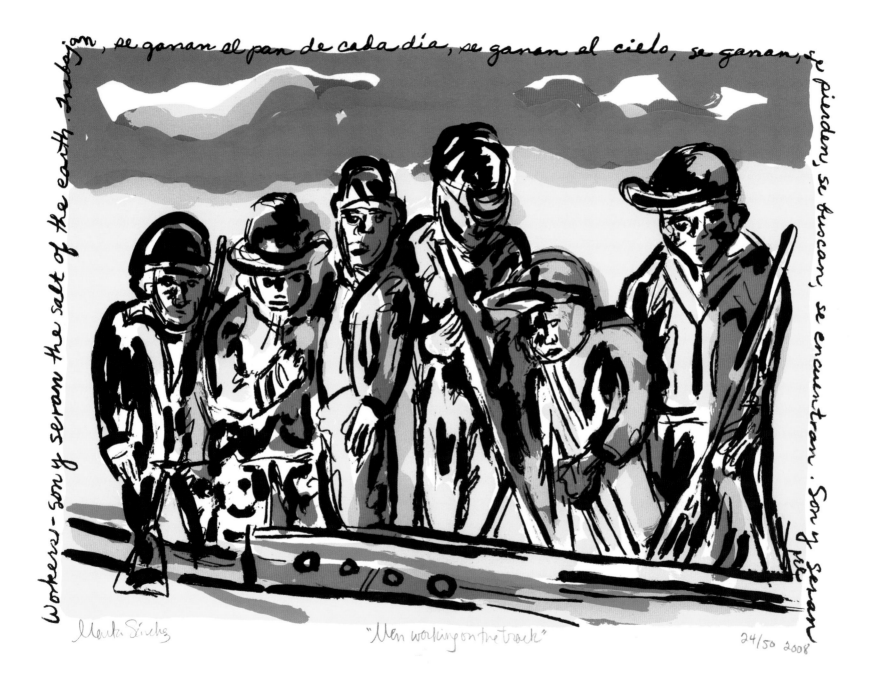

on, se ganan el pan de cada día, se ganan el cielo, se ganan, se pierden, se buscan, se encuentran. Son y serán

Workers- son y serán the salt of the earth. Trabaj

Marta Sánchez

"Men working on the track"

24/50 2008

# TRAPEZE ⟫ TRAPECIO

Caminos y mas caminos,
unos van otros vienen,
pero todos llegan a su destino
Desencuentros del corazón,
meandering pathways,
veredas only traveled alone.
Sola.

Paths and more paths,
some go, others come,
but all reach their destination.
The heart's intricate paths,
veredas serpenteantes,
caminante solitaria.
Alone.

# ANGELS OF STEEL ⁊ LOS ANGELES DE ACERO

Pechera, cachucha,
botas-steel tipped worn with pride.
Angels of steel whisper
amid the silent noises of the yard.

Overalls, cap,
lleva con orgullo sus boots con punta de acero,
Ángeles de acero susurran
entre el ruido silencioso de las vías del tren.

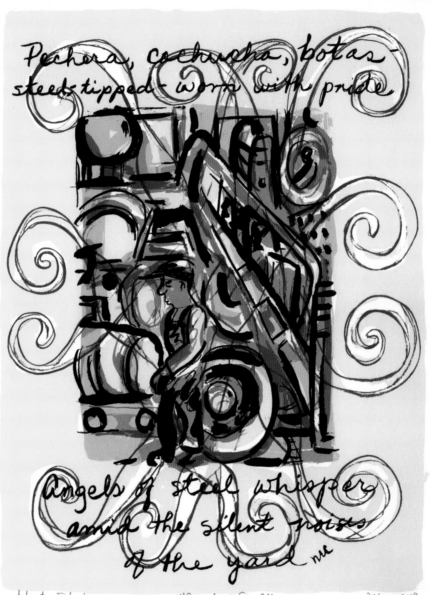

Pechera, cachucha, botas-
steel-tipped - worn with pride.

Angels of steel whisper
amid the silent noises
of the yard me

Marta Sánchez            "Angels of Steel"            24/50   2008

## SOLEDAD ⚭ LONELINESS

La Soledad nace del Corazón
Se anida en las células de mi ser
Como el pesar de cada día sin ti.

Loneliness is born in the heart
Nestles in the cells of my being
Like the weight of each day without you.

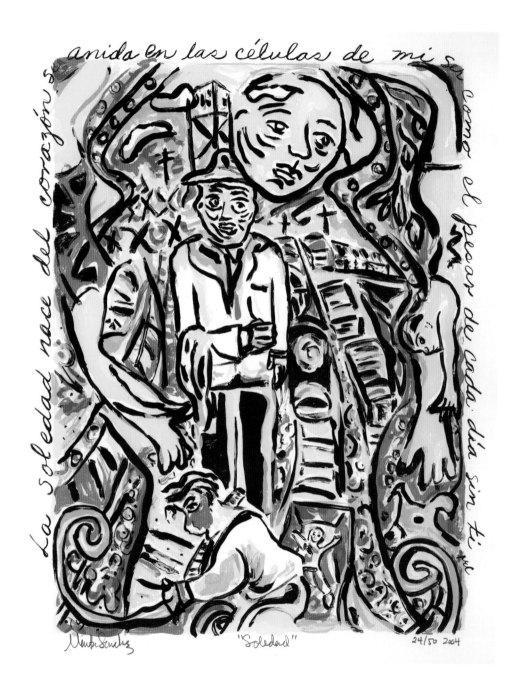

anida en las células de mi

La soledad nace del corazón se como el pesar de cada día sin ti

"Soledad"

24/50 2004

# HORIZON ⌘ HORIZONTE

R con R cigarro, R con R barril
que recio corren los carros, los carros del ferrocarril
waiting for trains, lives come to lives; trains follow tracks
leading to ends and beginnings
R con R cigarro R con R barril
que recio corren los carros, los carros del ferrocarril
Coming and going  —La vida es un tren y los pasajeros viajan siguiendo
su destino
Camarón que se duerme se lo lleva la corriente.
The engine hums a lullaby, reassuring whistle in the night,
R con R cigarro R con R barril
que recio corren los carros, los carros del ferrocarril.

R and R, cigarette, R and R, barrel
How fast those train cars run, the railroad cars!
En espera de los trenes las vidas llegan a otras vidas;
el tren sigue las vías que llegan al fin o al principio
R and R, cigarette, R and R, barrel
How fast those train cars run, the railroad cars!
Vienen y van —life is a train and passengers follow their destiny
The current takes the sleeping shrimp!
La máquina tararea una canción de cuna, silbido en la noche
R and R, cigarette, R and R, barrel
How fast those train cars run, the railroad cars!

R con R cigarro R con R barril que recio corren los carros los carros del ferrocarril~ Waiting for trains leading to lines to lives trains follow tracks leading to ends and beginnings~ R con R cigarro R con R barril que recio corren los carros los carros del ferrocarril~ Coming that going la vida es un tren y los pasajeros viajan siguiendo su destino~ la mar que se duerme se la lleva la corriente~ el engine hums a lullaby the reassuring whistle in the night R con R cigarro R con R barril que recio corren los carros los carros del ferrocarril

Marta Sánchez    "Horizon"    24/50    2003

N E Cantú

# LAS CARPAS ✺ TENT THEATERS

Dancers, musicians, standup comics, actors
Llegan con la primavera—
tambourines and drum rolls.
La Chata en el ferrocarril
Rielera de siempre.
Sueños y lágrimas. Life.

Bailarines, músicos, cómicos, actores.
They arrive with the spring time—
tamborines y tamborazos
La Chata by railroad,
Eternal train traveler.
Dreams and tears. Vida.

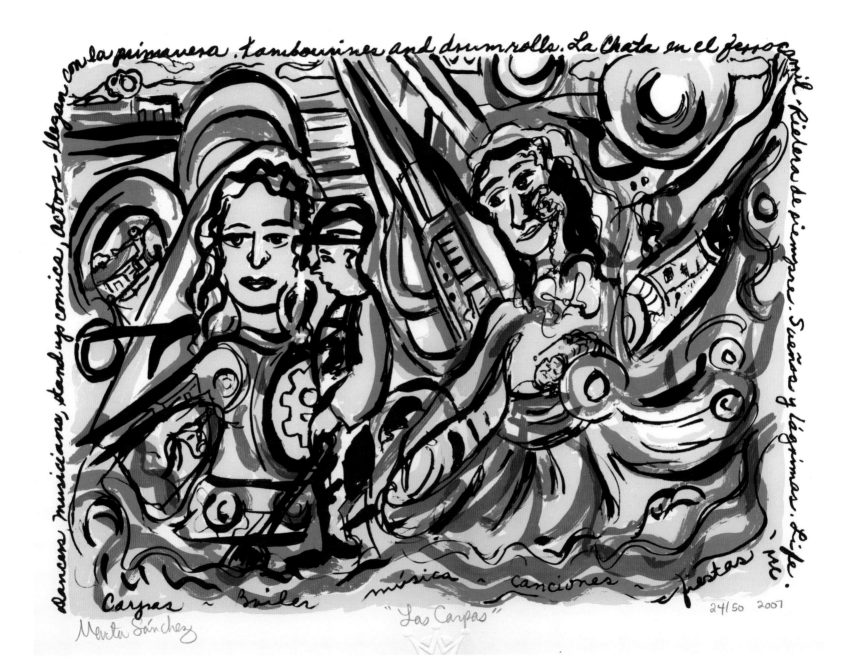

con la primavera. tambourines and drumrolls. La Chata en el ferrocarril. Rieles de siempre. Sueños y lágrimas. Life. mi

dancers, musicians, standup comics, actors— llegan

Carpas ~ Bailar          música ~ canciones ~ fiestas

"Las Carpas"

Merita Sánchez                                    24/50   2007

# A Contained Landscape, An Ambivalent Relationship: The Railroad and San Antonio's Mexican Colony

**Peter Haney, Ph.D.**

*L*andscape artists in the United States have tended to render the railroad in dramatic, panoramic perspective. In the most typical images, the tracks' sweeping straight lines dominate its surroundings, surpassing such natural wonders as mountains, canyons, and rivers. Outstripped by the mechanical marvel, the landscape appears otherwise untouched in these images, and though the line dividing the artificial from the natural remains stark, nature seems free and unbounded. In artist Marta Sánchez's images of her native San Antonio's rail yards, however, we see landscapes through gaps in chain-link fences, windows, and a screen door grille. Many of the views here are from inside a house or outside a fence, and the trains themselves, lined up on parallel tracks, form an impenetrable wall. In some images, the human body and landscape merge, both scarred by the passing of the rails. In the midst of it all, an acrobat arches her back in a handstand over the ghostly trace of window bars, her graceful legs crossed by telephone wires.

Drawing on memories of growing up near a rail yard and a family history of connection to the world of carpas, traveling tent shows that sometimes toured on the rails, Sánchez offers viewers an intimate portrait of a home landscape profoundly shaped by its conversion into someone else's destination or way station. It is hard to speak of the railroad without referring to its capacity to overcome geographical limitations, but Sánchez's images invite us to see how the train could raise barriers between neighbors even as it made San Antonio a neighbor to the ocean.

Perhaps we needed an artist from the so-called Alamo City to remind us that people already lived in the Western territories that railroad companies, helped by federal subsidies and military force, opened up for development after the Civil War. When workers finished the first rail line from the port of Galveston to San Antonio in February of 1877, they brought new life to a community already shaped by a transcontinental trade system that predated annexation to the United States. Many of the ethnic Mexican mule drivers who had dominated the city's once-thriving cart industry still lived there as laborers years after their violent dislocation from the trade at Anglo hands. Recently, however, economic growth had been slow, and without this vital new link to the coast, San Antonio would never have "boomed" the way it did in the late nineteenth century. As connections to points

North and West multiplied, the city became an attractive target for investors and new settlers from Europe and the Eastern Seaboard. English-language journalism of the time betrays the shock many newcomers apparently felt as they stepped off the train in San Antonio. The writer who asked, "*This* is the United States?" at the sight of a crowd of ethnic Mexican vendors outside the station is typical. As new arrivals came to outnumber the city's Mexican community, they came to see that community as a fading remnant of a bygone age. The depots, whose style recalled the old Spanish missions, helped make that age into a romantic myth. Decades before the Riverwalk, the railroad companies were already starting to remake San Antonio as a touristic mockup of the Spanish/Mexican agrarian society they had done so much to overwhelm.

But if the railroad depots memorialized an imagined Spanish colonial past, the rail lines themselves would increasingly become monuments to Mexican labor in the present. After the passage of the Chinese Exclusion Acts of 1882 and 1884, railroad companies turned to other ethnic groups to meet their labor needs. As the tracks expanded through the border region, ethnic Mexican workers from the country's central plateau moved north to join displaced local vaqueros on the section crews. Toward the end of the nineteenth century, railroads began recruiting Mexican laborers in the El Paso/Juárez area and sending them to construction and maintenance jobs all over the United States. In doing so, they started a pattern that agricultural companies all along the border would emulate in the early twentieth century as commercial farming boomed, aided by modern transportation. Both railroad and agricultural labor were strenuous and dangerous, and the itinerant workers faced a social stigma in the communities they passed through and segregation on the trains themselves.

Though they were barred from membership in most railroad unions, Mexicana/o laborers organized spontaneously throughout the Southwest to obtain better wages and working conditions. Those who settled in Southwestern and Midwestern towns were often forced to live in separate enclaves "across the tracks" from their Anglo neighbors. Although San Antonio's dividing line was San Pedro Creek, rather than the railroad tracks, the rail yards and the main station left a mark on what became the city's West Side. There, the small wooden frame houses that were built around the railroad corridor all over the U.S. Southwest in the 1920s and 1930s are still in evidence today. If the introduction of the railroad had displaced the ethnic Mexican community in San Antonio in the nineteenth century, the city's reorganization around rail-centered commerce eventually led to that community's rebirth in the twentieth. With this rebirth came the florescence of Spanish-language entertainment, as carpas, circuses, dramatic companies, and other performing arts groups used the railroads to travel from town to town.

Although most students of railroad history pinpoint the beginning of the industry's decline around 1920, with the advent of commercial trucking, the drive to recruit Mexican nationals for railroad labor continued through World War II and even after. During the war, the Federal government got into the act, negotiating a railroad bracero agreement with Mexico whose success in the eyes of its framers contrasts with the "failures" of

its agricultural counterpart. Although it is not today the center for recruitment of agricultural labor that it was in the early twentieth century, San Antonio remains the tourist town that the railroads helped fashion.

Military bases and military support industries in the city have provided many of the early Mexicana/o rail and agricultural employees' descendants with a measure of social mobility. Today, a solid Mexican American middle class lives alongside a working class that is more likely to be found in a hotel or a restaurant than on a section crew. The railroad still hauls goods to and from the city, and the trains still weave their rhythm into the lives of those who live near the rail yards. But the city's historic passenger rail stations, along with most of the theaters built for Spanish-language entertainment in the early twentieth century, have been bulldozed or converted into museums. Today, IH-35 blocks the view of the old central station from Milam Park, once the site of a thriving market fed by the railroad. The rise of the automobile industry and its collusion with various levels of government have reshaped the urban landscape of San Antonio and most other Western cities to support the sham individualism of personal cars on publicly funded roads.

Now the railroad, once lionized by boosters as the symbol of Progress, once reviled by populists as an iron octopus strangling the nation, stands as an object of nostalgia. The Spanish-language commercial theater industry represented by the carpas, which succumbed to competition from films after weathering war-era shortages and losing some of its brightest stars on the battlefields, also inspires nostalgia. In Marta Sánchez's art and Norma E. Cantú's poetry, both the carpa and the rail yard emerge as reoccurring dream images in which personal pleasures and collective traumas repeat themselves to the tune of the old tongue-twister, "erre con erre cigarro, erre con erre barril. Qué recio corren los carros, los carros del ferrocaril."

---

Dr. Peter Haney is the Assistant Director of the Center for Latin American & Caribbean Studies at the University of Kansas. He received his Ph.D. from the University of Texas at Austin, and has taught there and at Colorado College and Colorado State University / Pueblo. He has studied and written extensively about the role of tent shows and theatrical performance in the formation of San Antonio's ethnic Mexican community, in particular, and more generally about Mexican immigrant performance and media culture.

# The Transcendental Journeys of Marta Sánchez

## Constance Cortez, Ph.D.

The arrival of the steam engine marked the second half of the Industrial Revolution and, like most 19th century revolutions, this one had its critics. Positivists hailed the development of industry as a harbinger of a new era that would advance man's economic and scientific possibilities. Those falling on the other side of the issue viewed technological advances, such as the railroad, with skepticism and portrayed scientific discoveries as enemies of the natural world. Visual artists of the nineteenth century played out these opposing positions on their canvases. In the Americas, José María Velasco integrated the train into his panoramic landscapes, where they became celebratory markers of civilization and Mexican nationalism. In England, Romantic artists such as J.M.W. Turner clearly fell on the side of nature, underscoring tensions between the steam engine and the sublime qualities of nature.

To most artists, the basic human cost of creating railroad lines seemed peripheral to the larger, epic struggles regarding nature and manifest destiny. By mid-century, however, writers began to take note of the toll on workers who toiled to realize industrialist dreams. Nineteenth-century transcendentalist Henry David Thoreau, clearly an opponent of the railways, problematized the relationship of the worker and this new technology when he wrote:

> We do not ride on the railroad; it rides upon us. Did you ever think what those sleepers [railroad ties] are that underlie the railroad? Each one is a man, an Irishman, or a Yankee man. The rails are laid on them, and they are covered with sand, and the cars run smoothly over them. They are sound sleepers, I assure you. And every few years a new lot is laid down and run over; so that, if some have the pleasure of riding on a rail, others have the misfortune to be ridden upon. And when they run over a man that is walking in his sleep, a supernumerary sleeper in the wrong position, and wake him up, they suddenly stop the cars, and make a hue and cry about it, as if this were an exception. I am glad to know that it takes a gang of men for every five miles to keep the sleepers down and level in their beds as it is, for this is a sign that they may sometime get up again. (*Walden*, 1854)

It is clear that Thoreau understood the intimate connection between worker and industry, though it is from the vantage point of a nascent industry. But, what of later perspectives? In the almost 200 years since the creation of the locomotive engine, the train has become something other than a marker of the future; it is a marker of our past. Trains have entered our consciousness as part of our collective and, sometimes, personal histories.

Artist Marta Sánchez gives voice to the position of trains in the twenty-first century in a suite of ten images, each of which are surrounded by the words of writer Norma Elia Cantú. Sánchez's perspective on railroads is uniquely intimate and even familial. Growing up across from the train yards of San Antonio, Sánchez spent her youth hearing tales of the early twentieth-century trains that transported Mexican *carpas* (circuses and tent theaters) from town to town in South Texas. One such train delivered her great-grandfather, a Mexican lion tamer, to San Antonio. There, he fell in love with and married Sánchez's great-grandmother. To the young Marta, trains became part of the family's origin mythology and were honored subjects of some of her earliest drawings. In her child's imagination, the serendipitous meeting of her great-grandparents through locomotive agency transformed trains into benevolent gift-givers. Like wrapped presents on Christmas morning, Marta pondered the content of each railroad car.

At the same time, the romance of the trains and her excitement over their unknown cargo were always tempered by the reality of workers who labored daily in the train yards. From the vantage point of her family's front porch, Sánchez watched the men as they strained to maintain the trains and track, hard work exacerbated by the high temperatures and humidity of the city. Strikes marking the early part of the century had by then become part of the history and collective consciousness of the railroad workers in San Antonio. Such ambiguities—the gifts brought by rail and the toll on those who made the railroad possible—are embedded in the imagery found in this body of works by Sánchez.

*Las Carpas* (2007) celebrates daily life, on the one hand, and the infinite experiences offered by the arrival of the circus on the other. Her citing of disparate activities in a rail yard seems appropriate; the term "circus" is often used to describe the intersection of roads and people as well as the overwhelming tumult sometimes brought about by such gatherings. Swirls of activity are defined by the artist through her use of primary colors. The train and track, a rainbow of diagonal parallel lines emanating from the heavens, terminate in a dancer who flamboyantly displays her skirt in a show of colors and possibilities. The performer's benevolent gaze, and the relief her performance offers, is directed toward a rail worker who busies himself under the protective regard of the Virgin Mary. Surrounding the pair, houses, fields, and machine parts allude to the realities of work and family. Cantú's text unites these diverse experiences: *Dancers, musicians, standup comics, actors / Llegan con la primavera— / tambourines and drum rolls. / La Chata en el ferrocarril / Rielera de siempre. / Sueños y lágrimas. Life.*

Yet life's dreams are sometimes hard to remember as one becomes lost in the necessary task of work. In *La Cena* (2007), nameless workers, bathed in the blue of dusk, gather around tables to take their evening meal before returning to work. A sea of hats and helmets bespeak the anonymity of being part of an industrial machine and the subdued wash of color, overlaying the surface of the print, enhances the notion of a shared common plight. The struggle to maintain human connection, despite the forces of alienation that are part of industry, are reflected in Cantú's text:

> *Alone with others a (wo)man forgets*
> *(s)he is not alone.*
> *Juntos. El Pueblo Unido.*
> *Sí.  No.*
> *Jamas sera vencido.*
> *Juntos*
> *we eat, meet, talk, sing.*
> *Somos nada.*
> *Somos todo.*

We are nothing, we are everything—the mantra supplements Sanchez's imagery as the workers bow their heads in solitary contemplation *(prayer?)*.

A decidedly more defiant stance is taken by the subjects in *Workers on the Track* (2008). Here, six workers install a rail. Five examine the placement of the iron beam while a sixth sets his eyes upon an unseen observer. Strong and tall, with his chin thrust forward and his eyes set, his attitude speaks to the dignity demanded of his labor. While his identity remains unknown, we are forced to acknowledge and respect his presence, his human-ity: *Workers son y serán, / the salt of the earth. / Trabajan, se ganan / el pan de cada día, / se ganan el cielo. / Se ganan, se pierden, / se buscan, se encuentran. / Son y serán.*

This hard and necessary work, though often unsung, is given heroic proportions here. Like all unspoken heroes, these men, through their acts, earn their heaven.

Respite from labor and transcendence from temporal and geographic constraints are offered in *Moonlight* (2008) and *Prelude* (2003). Both images have as their emphasis bodies in repose. In *Moonlight*, comforted by the rhythm of passing trains, men sleep in the safety of their worker's cabins. Like the train cars before them, the workers lie end-to-end and are transported to different places and times via their dreams; all the while, protec-tive moonlight shelters the laborers on their nocturnal journeys. The prayer which arcs over the entire tableau is as much an apotropaic device as it is a petition for guidance: *Moonlight Vigilant guardian, / Luna guerrillera, / we*

*ask, / we plead, / soften the pain / with your light, / Coyolxauhqui help us / remember our true selves / ¡Gracias!* Cantú notes that the invocation of the Pre-Columbian moon goddess, Coyolxauhqui, reminds us that, "this land was once Mexico and that the contemporary overlay covers that which is much older." The past and geography merge and eternally inform the present.

The train in *Prelude* passes by a young man or boy, stretched out beneath a fiery sky. In this representation of death, Sánchez references Frida Kahlo's famous "The Deceased Dimas" (1937). But unlike Frida's regally bedecked child, this *angelito* has only his blanket to cover him. From his child's head, patterned lines radiate—highways and footpaths that bespeak travels taken in life and, perhaps, those spiritual journeys yet to come. Flowers that would normally surround the boy have been replaced by prayer cards, madonnas keeping vigil over the body of a child. Cycles of life and death, day and night, are in step with the ubiquitous cadence of the train:

> *Fiery gold crown*
> *sunset over Mexico*
> *death defies life*
> *A packed train speeds by*
> *transports precious cargo*
> *Arrives with the moonlight*

The historically dominant position of the train has passed, as have the utopian and apocalyptic visions posited by Turner, Velasco, and Thoreau. Infused with national, local, and personal histories, the particular meanings that we associate with railroads have surely become infinitely more complex. For Marta Sánchez, trains and train yards are sites of struggle and wonder and dreams. They are transcendental loci, and it is through her journey and her art that she shows us the possibilities of discovering the nature of divinity and joy in the environment that surrounds us.

---

Dr. Constance Cortez is Associate Professor in the School of Art at Texas Tech University, focusing on Chicano/a Art History and Post-Contact Art of Mexico. She received her PhD from the University of California, Los Angeles. She is the author of *Carmen Lomas Garza* (UCLA Chicano Studies Research Center and the University of Minnesota Press, 2010), which won first place for Best Arts Book (English) at the 2011 International Latino Book Awards, and *The Mayan Enigma* (Weidenfeld Nicolson, 1997). She was a co-editor of *Death and Afterlife in the Early Modern Hispanic World* (University of Minnesota Press, 2010) and the editor of *Imágenes e Historias/Images and Histories: Chicana Altar-Inspired Art* (Tufts University Gallery, 1999).

## Marta Sánchez

**B**orn and raised in San Antonio, Texas, Chicana painter Marta Sánchez is deeply inspired by traditional Mexican folk art expressions. Sánchez is recognized primarily for her Retablos paintings, an offspring of traditional Mexican prayer paintings. These soulful works on metal capture the deepest held wishes and dreams of her subjects, as if the artist were lighting a candle in prayer for her subject. Her works on paper are mostly linocuts, serigraphs and monotypes that also follow the social and cultural traditions of Mexican and Chicano/a Art.

Sánchez worked for years on the series of paintings of the San Antonio train yards near her childhood home that became *Transcendental Train Yard*. Through these paintings, she explores the role of trains in Mexican migration, and the carpas, traveling circus and vaudeville troupes that performed throughout Mexico. The family connection to this series is Marta's great-grandfather, who was a lion tamer in Mexico City and died at a young age from a puncture wound received from a lion.

Private individuals, as well as the collections of the Fine Art Museum of St. Petersburg, Florida, the State Museum of Pennsylvania, and the Print and Paper Collection of the Free Library of Philadelphia have collected Sánchez's works. Her work is part of actor/director Cheech Marin's extensive private collection of Chicano Art that became a traveling exhibition, "Chicano Visions: American Painters on the Verge". The exhibit toured the United States from 2001 to 2007. Marta's public art commissions can be seen in the Philadelphia area at Simons Recreation Center and the Children's Hospital in Montgomery, Pennsylvania.

Marta Sánchez earned her MFA in Painting from the Tyler School of Art, Temple University, and a BFA in Painting from the University of Texas at Austin. She teaches at The Philadelphia Museum of Art, St. Joseph's University, Springside School and Temple University's ART START program. She is a co-founder of the grassroots organization, "Cascarones Por La Vida," which assists families affected by HIV/AIDS. Marta resides in Philadelphia with her husband, John, and son, Phillip Ignacio. Her work has been published by Running Press and various other Chicano/a Art publications. For more information visit her website at www.artedemarta.com.

## Norma Elia Cantú

A few months after her birth in Nuevo Laredo, Mexico, in 1947, Cantú's family moved to Laredo, Texas, where she lived for the next 25 years. After attending public schools in Laredo, she received degrees from Laredo Junior College, and Texas A&I University at Laredo (BS in Education, majoring in English and Political Science) while working at a local utilities company. She then attended Texas A&I, Kingsville and the University of Nebraska, Lincoln, where she received MA and PhD degrees, respectively. For over 30 years she taught in South Texas, first at her alma mater, now Texas A&M International University, and at the University of Texas, San Antonio, with brief stints in Washington, DC (working at the National Endowment for the Arts), and in Santa Barbara (at the University of California, Santa Barbara).

Norma has received two Fulbright-Hays fellowships to do research in Spain; her novel, *Canícula: Snapshots of a Girlhood en la Frontera*, received the Aztlán Prize in 1996. She has published poetry, fiction and scholarly essays. Other projects include co-edited and edited work such as, *Telling to Live: Latina Feminist Testimonios, Dancing across Borders: Danzas y Bailes Mexicanos, Paths to Discovery: Autobiographies of Chicanas with Careers in Mathematics, Science and Engineering, Moctezuma's Table: Rolando Briseño's Chicano and Mexicano Tablescapes, Chicana Traditions: Continuity and Change*, and *Ofrenda: Liliana Wilson's Art of Dissidence and Dreams*.

As a community activist in Laredo, Norma was instrumental in the founding of the Literacy Volunteers organization (LVA); a feminist women's group, Las Mujeres; and a local chapter of Amnesty International; as well as organizing annual celebrations commemorating the anniversary of César Chávez's birthday. She sees her creative writing and academic work as forming a part of her activist agenda where academic study can inform and provide an impetus for social change. Active in a number of professional organizations, she also works with Mujeres Activas en Letras y Cambio Social and was named the 2008 Scholar of the Year by the National Association of Chicana and Chicano Studies. She founded the Society for the Study of Gloria Anzaldúa and is a founding member of the CantoMundo Poetry Workshop.

She is currently working on a number of book projects, including a collection of poetry, "Border Meditation/Meditación fronteriza: Poems of Love, Life and Work," two novels (tentatively titled, "Champú: or hair matters" and "Cabañuelas: A Love Story"), a long-range ethnographic study of the Matachines de la Santa Cruz, and a number of other creative and academic projects.

*W*ings Press was founded in 1975 by Joanie Whitebird and Joseph F. Lomax, both deceased, as "an informal association of artists and cultural mythologists dedicated to the preservation of the literature of the nation of Texas." Publisher, editor and designer since 1995, Bryce Milligan is honored to carry on and expand that mission to include the finest in American writing—meaning *all* of the Americas, without commercial considerations clouding the decision to publish or not to publish.

Wings Press intends to produce multi-cultural books, chapbooks, ebooks, recordings and broadsides that enlighten the human spirit and enliven the mind. Everyone ever associated with Wings has been or is a writer, and we know well that writing is a transformational art form capable of changing the world, primarily by allowing us to glimpse something of each other's souls. We believe that good writing is innovative, insightful, and interesting. But most of all it is honest. As Bob Dylan put it, "To live outside the law, you must be honest."

Likewise, Wings Press is committed to treating the planet itself as a partner. Thus the press uses as much recycled material as possible, from the paper on which the books are printed to the boxes in which they are shipped.

As Robert Dana wrote in *Against the Grain,* "Small press publishing is personal publishing. In essence, it's a matter of personal vision, personal taste and courage, and personal friendships." Welcome to our world.

*Colophon*

This first edition of *Transcendental Train Yard*, by Marta Sánchez and Norma Elia Cantú, has been printed on 140 gsm matte art paper containing a percentage of recycled fiber. Titles have been set in Dakota Handwritten type, the text in Adobe Caslon type. This book was designed by Bryce Milligan, a grandchild of both station masters and hoboes, who lives close by the train yards of San Antonio.

On-line catalogue and ordering:
www.wingspress.com
Wings Press titles are distributed to the trade by the Independent Publishers Group
www.ipgbook.com
and in Europe by Gazelle
www.gazellebookservices.co.uk

*Also available as an ebook.*

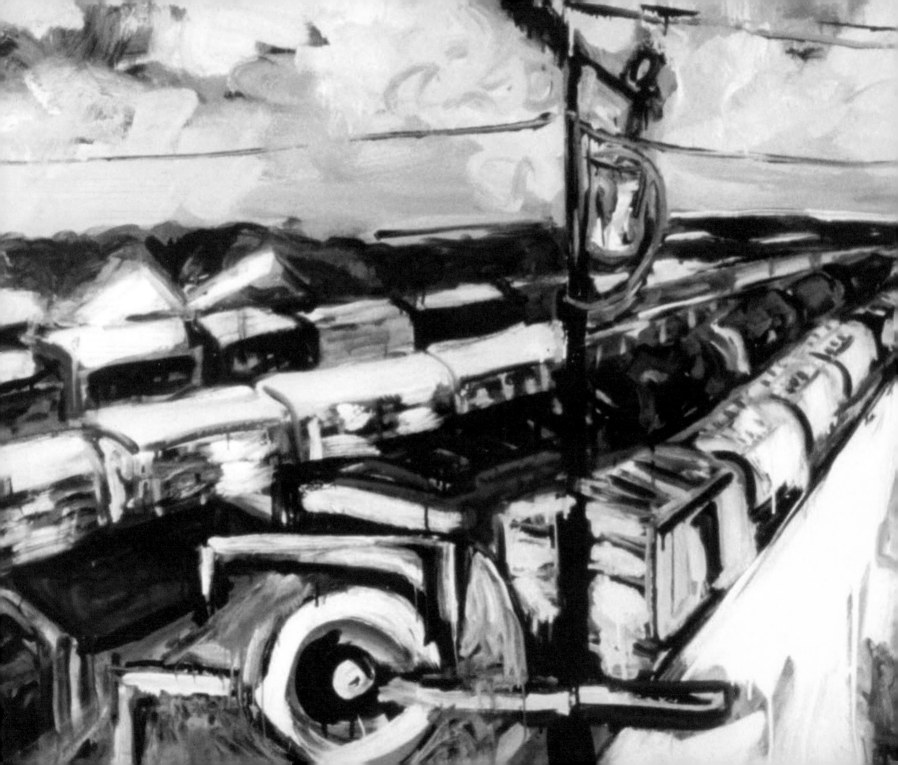